IMMA Series (2)

Irish Museum of Modern Art

Rachael Thomas
Interviews

Michael Craig-Martin

CHARTA

Editor
Rachael Thomas, Senior Curator Head of
Exhibitions

Assistant Editor
Nicola Lees, Assistant Curator New Galleries

Compiled by
Maeve Butler, Curatorial Assistant
and Seán Kissane, Curator Exhibitions

Copy Editing
Lise Connellan
Emily Ligniti

Design
Daniela Meda

Editorial Coordination
Filomena Moscatelli

Copywriting and Press Office
Silvia Palombi Arte&Mostre, Milano

Web Design and Online Promotion
Barbara Bonacina

Cover
On the Table, 1970
Wood, metal, water, rope
122 x 122 cm, height variable
Collection Irish Museum of Modern Art
Purchase, 2004

Photo Credits
pp. 52–53 Juan Garcia Rosell

We apologize if, due to reasons wholly beyond
our control, some of the photo sources have not
been listed.

No part of this publication may be reproduced,
stored in a retrieval system or transmitted in any
form or by any means without the prior
permission in writing of copyright holders and of
the publisher.

Edizioni Charta
via della Moscova, 27
20121 Milan
Tel. +39-026598098/026598200
Fax +39-026598577
e-mail: edcharta@tin.it
www.chartaartbooks.it

Irish Museum of Modern Art/Áras Nua-Ealaíne
Na hÉireann
Royal Hospital, Military Road, Kilmainham,
Dublin 8, Ireland
Tel + 353 1 612 9900
Fax + 353 1 612 9999
email info@imma.ie
www.imma.ie

Printed in Italy

Published on the occasion of the exhibition
Michael Craig-Martin,
Irish Museum of Modern Art
7 October 2006 – 14 January 2007

Director
Enrique Juncosa

Senior Curator Head of Exhibitions
Rachael Thomas

Curator Exhibitions
Seán Kissane

Assistant Curator Exhibitions
Karen Sweeney

Acknowledgements
IMMA would like to thank
Michael Craig-Martin
Ian Cooke
Gagosian Gallery, London
Giuseppe Liverani
Brian Cass and Eimear O'Raw

Contents

Foreword

Michael Craig-Martin was born in Dublin in 1941. Although he lived in England and Wales until the end of World War II, his family eventually moved to Washington, DC, where he began his education. However he would visit Dublin during the summer every three years. Craig-Martin went to Yale in the early sixties, studying Painting; there he met graduate students Richard Serra, Brice Marden and Chuck Close. In 1966, after seeing the *Primary Structures* (Sol LeWitt, Donald Judd, Carl Andre, Robert Morris) exhibition at the Jewish Museum in New York, he accepted a teaching post in Corsham, England. His first exhibition took place in London (1969), and he has since shown a number of times in Dublin, at the Oliver Dowling Gallery, the Douglas Hyde Gallery and the Irish Museum of Modern Art (IMMA) in group exhibitions. In the autumn of 2006, the second retrospective of his work will take place at IMMA, following the one held at Whitechapel Gallery, London (1988).

During the last three years IMMA has made a considerable effort to include Michael Craig-Martin's work in its collection, first buying the seminal conceptual piece *On the Table* (1970). This was followed by the acquisition of a major painting *Eye of the Storm* (2003). Recently, the artist donated another early work, *Film* (1963), which remains his only film to date and was shot in Connemara during his student days. While it would be difficult to summarise a long career in these different works, IMMA owns three representative pieces from important periods in the artist's stylistic development.

In this book, Rachael Thomas, Senior Curator Head of Exhibitions at IMMA, discusses with the artist his connections to minimalism which in 1966, on his arrival to England, was virtually unknown except to assiduous readers of such

American magazines as *Artforum*. Thomas and Craig-Martin discuss the transition from Greenbergian formalism to a hydra-headed activity involving process, anti-form, conceptual and land-based activity. Stimuli for this came from Josef Albers's revolutionary teaching methods at Yale, John Cage's *Lecture on Nothing*, the complete retrospective of Duchamp's oeuvre held at Tate Gallery (1966) and the international exhibition devoted to the new modes, *When Attitudes Became Form*, at the ICA in London (1969), which was first shown in Switzerland and curated by Harald Szeeman. The interview also investigates many conceptual concerns, semiotics and ultimately the functions of art and language.

Craig-Martin held a teaching position at Goldsmiths College in London, were he influenced a whole generation of younger artists. He also curated a seminal exhibition about drawing, *Drawing the Line*, at the Whitechapel Gallery in London (1995). In recent years, his work has been seen in major museums all over the world including Centre Georges Pompidou, Paris (1994), Museum of Contemporary Art, Chicago (1995), Düsseldorf Kunstverein (1997), XXIV Bienal de São Paulo (1998), MoMA, New York (1999), IVAM, Valencia (2000), Sintra Museum of Modern Art, Lisbon (2001), Le Magasin, Grenoble (2005) and Kunsthaus Bregenz (2006).

I would like to take the opportunity to thank everyone involved in this publication, Rachael Thomas and Nicola Lees at IMMA, and Giuseppe Liverani and his team at Edizioni Charta in Milan, especially the graphic designer Daniela Meda. Finally my heartfelt thanks to the artist for his friendship and his gracious and generous commitment to this project.

Enrique Juncosa, Director

Rachael Thomas Interviews Michael Craig-Martin

Michael Craig-Martin

Michael Craig-Martin was born in Dublin in 1941 and brought up in the United States, studying Fine Art at Yale University School of Art and Architecture in the early sixties, when the teaching legacy of Joseph Albers (Yale, 1950–1958) was still extremely prominent. He returned to Britain in the mid-sixties where he became one of the key figures of the first generation of British conceptual artists. His first solo show was at the Rowan Gallery, London (1969). Since that time, he has exhibited in numerous solo and group exhibitions both in Britain and abroad, including the definitive exhibition of British conceptual art, *The New Art*, curated by Anne Seymour at the Hayward Gallery, London (1972). His work has been concerned with fundamental questions about the nature of art, about representation, authorship, the role of the viewer, explored primarily through commonplace objects both real and as images. His best known works include *An Oak Tree* (1973), and his recent intensely coloured room installations and paintings. From 1974 to 1988, he taught at Goldsmiths College, London, where he was appointed Millard Professor of Fine Art (until 2000). His teaching methodology was strongly influenced by his experiences at Yale. In 1989, a major retrospective of his oeuvre was held at the Whitechapel Art Gallery, London. In 1995, he curated *Drawing the Line*, a touring exhibition of drawings from pre-history to the present day that was shown in London at the Whitechapel Gallery. In 1998, he represented Great Britain at the XXIV Bienal de São Paulo in Brazil. He has created many large-scale installations including those at the Kunstverein Hannover 1998, the Museum of Modern Art in New York in 1999 and IVAM in Valencia in 2000. He was appointed a Trustee of the Tate Gallery, London, from 1989 to 1999.

Rachael Thomas

Rachael Thomas is Senior Curator Head of Exhibitions at the Irish Museum of Modern Art, Dublin. Thomas has curated various exhibitions including solo surveys of the American Fluxus and feminist artist Eleanor Antin, Thomas Ruff, Karen Kilimnilk, Margherita Manzelli, Sophie Calle and Mark Manders. She has introduced a new project strand to IMMA, bringing to Ireland solo and group projects by young international artists such as Franz Ackermann, Pierre Huyghe, Thomas Demand and Anri Sala. Group exhibitions include *All Hawaii Entrées / Lunar* Reggae with artists such as Philippe Parreno, Doug Aitken, Sarah Lucas, Jim Lambie, Liam Gillick, Douglas Gordon, Carsten Höller, Jorge Pardo, Anri Sala and Rirkrit Tiravanija. Thomas was awarded a Millennium Fellowship to produce papers on global frameworks of contemporary art practice at Tate Britain, London. In 2000, she initiated the first platform for Wales at the Venice Biennale with the intervention in The Art Newspaper; *When the Dragon Wakes* with Cerith Wyn Evans. In 2006, Thomas curated the Irish Pavillion, New Territories, ARCO 06, Madrid. She has lectured on the role of the curator at various symposiums such as *Curating Now* and *The Role of Painting in the 21st Century*. As a writer she has published widely in journals and exhibition catalogues including texts on artists such as Eleanor Antin, Sophie Calle, Pierre Huyghe, Alex Katz, Paul Morrison and Thomas Schibeitz.

The following is a series of conversations that took place in London and Dublin, December 2005.

Rachael Thomas: Michael, you have previously referenced to the lectures and writings of the experimental music composer, writer and visual artist John Cage (1912–1992). Could you start this discussion by elaborating on how Cage's revolutionary ideas possibly influence your own practice?

Michael Craig-Martin: One of the most important things I read when I was a student was John Cage's *Lecture on Nothing* (ca. 1947).[1] It was unlike anything I had ever read, overwhelmingly radical and original, but in a way that seemed to speak directly to me.

The lecture was written as though it were a musical composition – it has structure, pace, rhythm. Its subject is the lecture itself – I think this is probably the first truly self-referential work ever created. Cage doesn't just discuss his ideas about form and structure and content, he uses the lecture to give the audience a direct living experience of what he's talking about. He's doing what he's saying.

It's fascinating and confusing, sometimes boring, but also very funny. He regularly informs the audience how far along he is in the lecture – it should be reassuring, but is in fact increasingly horrifying. Towards

1. Here I am referring to the *Lecture on Nothing* by John Cage, *Silence, Lectures and Writings*. London: Marion Boyars, 1978.

the end he repeats a very long passage at least a dozen times. It includes the phrase 'slowly we are having the feeling we are getting nowhere'. It was this section I assume that drove most of the original audience running for the door. Anyway, I loved it and I still do.

When I had the chance in the seventies to speak to him I said how much it had meant to me, what an extraordinary thing it was to have written. He said he had no interest at all in that text anymore and had changed his mind about a lot of things in it. I was taken aback, but obviously a truly original mind is one that's not trapped in its own past.

RT: I'm thinking of Cage's patriarchal preoccupation with this notion of chance. That many of his compositions depend on chance procedures for their structure and performance. Cage states that 'one must give up the desire to control sound, clear his mind of music and set about discovering means to let sounds be themselves, rather than vehicles for man-made theories'. Do you feel the concept of 'giving up control' and letting the artwork be a discovery of freedom is therefore vital for an artist?

MCM: Yes, that's what it means to be thinking creatively. You can't force yourself to be creative. What I took from Cage was that you need to work with what you're given, not try to force it to do what you want, but to follow its leads. You never start with nothing – you have to be sensitive to what's there. Things are always up for grabs, and it does seem important to me to have a little bit of danger, artists have to be a bit in danger themselves, before you can really proceed. People, particularly today, want to feel the sensation of risk without having to take a real risk.

RT: Risk-taking can bring success, and this idea is an interesting one that I would like to talk more about. We fear taking risks because we might fail, but failure might be a positive thing.

MCM: It's a positive way of looking at failure, but when you actually feel like you are failing, it's just terrible. It is not really a risk unless there is a genuine possibility that it is going to fail. If you are very risk averse, if you want to get rid of all possible risk, then you are going to get rid of all possibility of actual success . . . and the more risky a thing is, there is a chance it is a mistake, there is a chance it's going to be wrong. But on the other hand, if it succeeds, it's much more interesting than something you've tried to build while avoiding the possibility that it could actually fail.

RT: Linking into that very idea, of chance, that leap of faith into the unknown, this has a risk aspect, too. I was also reminded of Marcel Duchamp's *The Bride Stripped Bare by Her Bachelors, Even (The Large Glass)* (1915–1923). This work seems to be a declaration of Duchamp's belief that art should be more than a surface image. The main position of this work seems to be a series of appropriations of authority and sensation. This could be a sense that there is a direct methodology in risk-taking and judgement. This work implies an element of 'chance encounters', but actually discloses manifest implications within the work. Do you then deliberately set out to be elliptical and elusory in the compositions of your work?

MCM: It seems to me that all work that interests me is work that acknowledges the role of the viewer in the completion of the work. It

should be possible for somebody else to participate in and recognise something. I've always felt that when I'm the audience, when I'm the viewer, that whenever you have the experience of seeing something that strikes you as extraordinarily new, it's like you've been waiting to see it, or waiting to hear it. The fact is you have actually already thought about it, but you've never been able to formulate it clearly, and so the act of seeing something new is actually the act of recognition. You recognise that someone else had a much clearer understanding of that thing, about which you had made only some kind of tentative sense.

RT: Yes, this idea of newness or this idea of radicalness is something you have often talked about within the piece, but really is it a way of increasing the vocabulary within the work? It's almost a constant onslaught of thought. I always feel when I'm looking at your work that I am captured, and that I can't leave. My breath is gone, just by looking at the explicitness of the domestic object (such as a fan or a ladder), this subject of the commonplace, this bears on the act of apprehension of the way the object is revealed. It seems like an act of transcendence. I just wondered whether you think beyond the viewer just standing there physically and emotionally in the room and the immediate impact of the work, the presence of the object resonates a sense of wonder? Or is it a longer-term resonance, which gives the spectator an experience of imaginative self-discovery?

MCM: All my work is based on an idea about the power of ordinary experience. I'm not interested in the idea of transcending that, or of some experience, which goes beyond, above or outside the ordinary. To me, all the truly extraordinary things about the world are con-

tained within ordinary experience and how it is dealt with. All the artists that interest me have done just that, and to me this is what's so special about Duchamp. Duchamp allowed us to recognise that anything in the ordinary world can be seen as art. Cage showed that any sound can be music, as music is about sound and all sounds are equal. I see these people as liberators of thinking. One of the things they have in common is the way they tried to find a direction towards greater inclusively rather than exclusivity.

RT: So, do you ultimately show everything that is crucial on the surface of your work, be it canvas, wall or computer screen? Or is there a trick with the viewer that something is hidden to us?

MCM: There isn't, but if there is a trick, the trick is shown, the trick is revealed. It seems to me it's very much what I wanted to do myself. I'm interested in looking back now at the artists who have influenced me the most. Someone who's been very important to me is Josef Albers.[2] I went to the Yale School of Art and Architecture where he taught for many years. However, I never met Albers, he had retired just before I arrived, but I studied all the courses that he invented.

2. The work of Joseph Albers (1888–1976) formed, both in Europe and in the USA, the basis of some of the most influential and far-reaching art education programmes of the twentieth century. He began teaching in the preliminary course of the Department of Design in 1922, and was promoted to professor in 1925, the year the Bauhaus moved to Dessau. With the closure of the Bauhaus under Nazi pressures in 1933, Albers emigrated to the United States and joined the faculty of Black Mountain College, North California, where he ran the painting programme until 1949. In 1950, he became Head of the Department of Design at Yale University in New Haven until he retired in 1958. In 1963, he published *Interaction of Colour*, which presented his theory that colours were governed by an internal and deceptive logic (op art).

RT: Talking about your practice, with this sense of immediacy, do you feel an allegiance with the medieval painter Giotto's work?[3] By this I was thinking of Giotto's use of the propinquity of the image, gesticulation and colour. His figures have simplicity of form, which in itself produces a transparency and clarity in meaning. As Giotto swiftly conveys a transmutation of meaning – a religious message. Therefore, does your work reveal through the simplicity of form a hidden message or an ideology?

MCM: I don't have a mission, but of all the periods of art, the one I feel most sympathetic towards is early Italian Renaissance art. I like the sense that you are watching them making discoveries. It's an amazing moment in human history. Also, what's very striking about somebody like Giotto or any of the great artists of that period is that they made works of immense complexity. They are at the border of human understanding in the complexity of what they are doing, and at the same time they are making works which are for a largely illiterate audience. It's extraordinary that the most educated person of the period – the ruler or bishop – could understand the work, and an illiterate peasant could come into a church and see the work and understand it as well. Of course this is not to say that their understanding is not different, but that the work does not exclude anybody.

I always liked the idea of trying to make works that are simple and sophisticated at the same time. I'm the person I am and I think the way I do, so I act out things in the way that I do. I make my work for myself, and hope it finds a resonance in others.

RT: Do you feel this inclusivity relates to your subject matter, which

could be seen as a representation of humanity? So many descriptions have been tagged onto you from so many quarters, but I am curious about this idea of removal and escaping which seems to figure in your work. Giotto's works are awash with humanity. Do you feel this conviction is within your work?

MCM: One of the reasons why the Renaissance was so rich in possibilities was because it was a very coherent society. Everybody agreed with everybody else about what was most important. Everybody believed in God (more or less). And not only that – they appeared to believe in the same God. There was the incredibly rich narrative from the Bible, from Christianity and from the history of the saints, and all of these things were widely understood within society. The reason Giotto's paintings were understood by the common man was that they knew by word of mouth what the story was and when they saw the pictures they could identify within the pictures the stories they had heard. There was a background of shared information that all the artists could draw upon. Therefore, there are hundreds of paintings of the Crucifixion and the Annunciation, and each artist could interpret it in a different way. But the story stayed, the narrative was there for everybody to recognise.

Today we are the complete opposite, as we live in very fractured societies. There are people who believe in God, and those who don't; there are people who believe in one god and others who believe in

3. Giotto di Bondone (1267–1337), better known as Giotto, was an Italian painter and architect. He is generally considered the first in a line of great artists who contributed to and developed the Italian Renaissance. He stands as the key link between the Byzantine art of the late Middle Ages and the more realistic and humanistic art which evolved during the Renaissance.

another. We have different values; we are extraordinarily fragmented for better or worse. My picture of our society is that the things that unite us, at a very simple level, are the ordinary things that we make in order to survive. The most universal manifestation of ourselves are the things that we make, ordinary things, books, tables, chairs, shoes and beer cans . . .

RT: In that light, do you take up the position of the aesthete's? Here, I was thinking of the quote by Susan Sontag, where she states: 'The idea that depths are obfuscating, demagogic, that no human essence stirs at the bottom of things, and that freedom lies in staying on the surface . . . The aesthete is constantly making an argument against depth, against the idea of hiddeness, as a mystification, a lie, but opposes the very idea of antitheses. To speak of depths and surfaces is already to misrepresent the aesthetic view of the world – to reiterate a duality, like that of form and content, it precisely denies.'⁴ Sontag deftly comments on the cultural position and values 'of the surface' and so my question is – do you actively reveal urbane objects which we place no value upon, and cast them into an iconic status that makes them highly visible?

MCM: I think that's true, and I think the best art, the most interesting art is not about invention, but observation and revelation. The recognition that something that has always been there, and usually undervalued, is suddenly in the foreground and is presented in such a way that it becomes valued. And I'm trying to indicate that there is so much of what we are in all of these things we make; that these are the expressions of ourselves and our time.

RT: Also, you are re-ordering those value systems. There are obvious traces of that idea of experience in the ordinary, of really looking at things, in Andy Warhol and many other people. Although it's well documented, I'd like you to quickly talk us through your relationship with the work of Warhol, and the British and American tradition. How the humdrum becomes the most exquisite beauty. How does that link to other contemporaries, or your forebears?

MCM: Well, various people interest me, particularly those who had this idea of a conceptual thread running through all their creative productivity. However, as soon as you try to create a larger picture of things, you are trying to accommodate a lot. I think it's important to say in this context that I grew up as a Catholic, though I am not a Catholic now. I don't believe in God, but I had a very good Catholic education. There is something very important about Catholicism; it attempts to account for everything, for heaven and earth, for men and for God, for evil, for the past and present, for the future that's going to happen and that has happened. Everything is accounted for in some way through Catholicism. And so I think this gave me an intellectual idea about the way in which the world is framed intellectually. I've lost the need for confidence in the picture that Catholicism presents, but what stayed with me is the desire to have a construct within which everything is accounted for. And the people who interest me are the people who made work that

4. Susan Sontag, "On Roland Barthes", in *Roland Barthes Selected Writings*. Glasgow: Fontana Paperbacks, 1983.

attempted to account for as much of everything as possible. Those people are Duchamp, Cage, Warhol and I have to say somebody like Donald Judd,[5] as he tried to find the most basic thing, sculpture, the most defining element for describing the whole phenomenon. This is what Warhol does with mediated imagery. He understands perfectly the notion that we've mediated the entire world, so by doing that he can do the Coke cans, he can do the celebratory, the automobile accident. He can do all that in painting, because all of these things have now been mediated. These are all simple attempts to account for a lot of the world. It's very nice to associate myself with such giants, but there you go. It has certainly been my ambition to be able to have some sort of a larger picture in the way that they do and I have to say there are many artists who I think are great artists, but I don't necessarily believe that all artists have this ambition. In Britain, the only artist who I think is clearly doing what I am talking about is Richard Hamilton and in Germany, the artist is obviously Joseph Beuys.[6]

RT: What about the younger artists today? What do you feel about the current process of this generation's artistic practice?

MCM: I think it's much harder to take the kind of overview that I'm describing for an artist today than it was even twenty or thirty years ago when I was a much younger artist. In terms of the people whom I have taught, I actually think two or three of them in different ways have tried to accommodate this larger picture. One of them is definitely Damien Hirst.[7] I think that he does try to make this attempt. The others are Julian Opie and Liam Gillick.

RT: Who do you think of the three has the greatest sense of romanticism?

MCM: The only one who is a romanticist is Damien.

RT: Do you feel that you are a romanticist?

MCM: No. I think I'm definitely not a romanticist. On the other hand, I think I'm a romantic. I'm a romantic in the sense that I'm an optimist, and there are a lot of people whom I've talked about in this interview that I loved when I was very young . . .
I love Samuel Beckett's[8] work and when I was young the people who interested me were the existentialists.[9] But I am a child of suburban

5. Donald Judd (1928–1994) was an American minimalist artist whose work sought autonomy and clarity for the constructed object and the space created by it, ultimately achieving a rigorously democratic presentation without compositional hierarchy. Andy Warhol (1928–1987) was an American painter, filmmaker, publisher and actor and a major figure of the pop art movement.
6. Joseph Beuys (1921–1986) was a German conceptual artist who produced work in a number of forms including sculpture, performance, video art and installations.
7. Damien Hirst (b. 1965) graduated from Goldsmiths College, London, in 1989. Julian Opie (b. 1958) attended Goldsmiths College, London, 1979–1982 and Liam Gillick (b. 1964) attended Goldsmiths College, London, 1984–1987.
8. Samuel Beckett (1906–1989) was an Irish playwright, novelist and poet. Beckett's work is stark, fundamentally minimalist and according to some interpretations, deeply pessimistic about the human condition. The perceived pessimism is mitigated both by a great and often wicked sense of humour. Works include the plays *Waiting for Godot* (1952), *Krapp's Last Tape* (1958) and *Endgame* (1957).
9. Existentialism (philosophical theory emphasising the existence of the individual person as a free and responsible agent determining his or her own development) was inspired by the works of Søren Kierkegaard, Fyodor Dostoevsky and the German philosopher Friedrich Nietzsche, Edmund Husserl and Martin Heidegger. It became popular in the mid-twentieth century through the works of the French writer-philosophers Jean-Paul Sartre and Simone de Beauvoir, whose versions of existentialism are set out in a popular form in Sartre's 1946 *L'Existentialisme est un humanisme*, translated as *Existentialism Is a Humanism*.

life, so I had a youthful fascination, in the way one does when one is a young and very serious teenager, with Ingmar Bergman, and I went to Sweden to meet him. But at the same time I was a teenager living in the United States, a child of rock and roll.[10] I was living in the suburbs and we had a big car with fins. It's very hard to be existential in these circumstances. So you can only be what you can be, and I assume from that early experience I have always been essentially an optimist. I think it's difficult to be an optimist without having a streak of the romantic in you because reality would obviously dim your optimism if you weren't so.

RT: It's interesting you mentioned Beckett, because I was thinking of a quote from another great Irish writer, W.B. Yeats: 'A line will take us hours, maybe, Yet if it does not seem a moment's thought, Our stitching and unstitching has been naught', which I think are very beautiful lines from his poem *Adam's Curse*. There could be a parallel between Yeats's notions of the elusive sense of grace that comes with the appearance of ease; this sense of graceful ease seems a seamless beauty in your work. This sensibility leads me to mention your relationship with Ireland. Do you feel an Irish kinship?[11]

MCM: I've been thinking a lot about Ireland, particularly because of the exhibition coming up and I can't tell you how pleased and happy I am to be doing this exhibition in Dublin. I have such a funny relationship with Ireland, because I was born in Dublin, but lived in the United States from the time I was three. I was essentially an American child, but at the same time it was different because from the moment we arrived in America, from the beginning of the forties,

my father had told me that hopefully we'd go back to Dublin for the summer and spend the time living at my grandfather's in Donnybrook. Suddenly, every three years I would be taken out of the American suburbs, with no relatives and no connections, and cast into the bosom of a big Irish family with uncles and cousins and grandparents and great aunts and great uncles, who were from very different worlds. This was the fifties; the world of Dublin could not have been more different from suburban America. Consequently, I've grown up with a sense of Irishness, but also with a crisis of identity, of feeling both comfortable and uncomfortable everywhere. I mean, I was born in one country, grew up in another and have lived my adult life in a third, and I'm equally at home and equally ill at ease in all of them. I've found that I've known many artists whose childhoods have some kind of fracturing. Anybody who has ever lived in a different country knows it's not like going on holiday. If you live someplace for some time, you tend to become an observer of the place you've come from. And as soon as you are able to become an observer of the place you come from, you never can go back to it the same way. I think many people who become artists become observers through this childhood displacement, which often has to do with being brought up in one country and born in another.

10. Ernst Ingmar Bergman (b. 1918) is a Swedish stage and film director who is one of the key film *auteurs* of the second half of the twentieth century. His films usually deal with existential questions about mortality, loneliness and faith; they are also usually direct and not overtly stylised. *Persona*, one of Bergman's most famous films, is unusual among Bergman's work for being existentialist and avant-garde.

11. William Butler Yeats (1865–1939) was an Irish poet, dramatist, mystic and public figure. This quote is from his poem *Adam's Curse*, published in 1904.

RT: Your artistic roots seem to lie 'within an immediate American background, the combination of sensibility, methodology and judgement which brings to bear an artistic practice that is strictly close to that of a paradigmatic aesthete'.[12] Therefore, this displacement galvanises this unique perspective, so ultimately, do you have a sense of belonging everywhere and yet nowhere?

MCM: One of the things I find extraordinary is that I had a sense when I was a child that it was a unique experience. And even coming to England in the sixties was a very unusual thing to do. Everybody said I was nuts – which was probably right. But if you look at the contemporary world, a quarter of the people in the world are living in a country that they didn't come from. This kind of displacement, of being born someplace and living someplace else, is now the common experience of a great proportion of humanity. In every part of the world, there are great populations of people who are displaced. Whether it's positive or negative, it's a very different world. So maybe my fragmented and unusual upbringing is closer than I would ever have imagined to the experience of a lot of people.

RT: Interestingly, your only ever film piece, made when you were twenty, was shot in Connemara, Ireland. I have to say that when I saw your black and white film I was blown away by its beauty, and by its resonance. Also, I felt like I was walking into a three-dimensional representation of one of your pieces. Does this work underpin or illustrate a defining principle of your practice? And can it explain or make transparent further issues about you as well?[13]

MCM: From my experience of teaching, I think that I've learnt that the fundamental roots of an artist's sensibility are already in place long before he or she goes to art school. And partly what happens can be seen in their childhood, and may get somewhat lost in early teenage years, and part of that is to go to art school and help them recover something of that inner self that's more available to them as children. I think that *Film* (1963) was done with a certain amount of innocence. Because I'd never taken photographs, let alone made a film before, and I'm certain I had almost no idea what I was doing. Yet all of the things that underpin my subsequent work are aesthetically within the film. Except for an essential element – that it doesn't contain any of the objects that people most readily associated with my work. But what it is about is ordinary experience. And the reason I went to Connemara, and I went looking to find the right place to make this film, was that I wanted to go to a place; it's very hard to describe it, without interest, without any obvious drama.

RT: I can see the beguiling simplicity of narrative within the film, and yet the disclosures of the film are manifest.

MCM: Simplicity – that is what I wanted. That's the non-romantic in me. I'm not looking for drama; I'm not looking for the big moment.

12. Lynne Cooke, *The Prevarication of Meaning*. London: Whitechapel Art Gallery, 1989.
13. Michael Craig-Martin, *Film*, 1963. Craig-Martin shot this film with a 16mm Bolex camera at Lettermore and Lettermullen in Connemara on the Atlantic coast of Ireland during the summer of 1962. The edited film was presented the following year as Craig-Martin's final project for his BA degree in Fine Art at Yale University.

But the thing that is on the screen is the fact of a blade of grass twitching just a tiny bit . . . that's enough. I felt this was a place of such stillness, such emptiness, so flat and so abandoned, with so little there – that was the subject that interested me. And I just stood there and shot the picture. I didn't do anything very elaborate, but to me those principles are exactly the same ones that influence my work to this day. This is what I was trying to say about having a larger picture, because of course other works of mine that are orange and purple and green or of big city landscapes don't look in anyway like that black and white film I made when I was twenty. But I'm not talking about style; I'm talking about an idea, a conceptual thread. On the one hand, in every picture there are simple things from everyday life, and from that point there are images, ideas and concepts that unfold and emanate from this one idea.

RT: When the film was shown at Lismore Castle in Cork, it received an overwhelming reception. There was a deep humanist aspect to your approach of projecting to the viewer that realm of ordinariness, which we are all familiar with and which links us together. I mean people were powerfully moved by it, and we should never underestimate our minds, our souls. I felt that response as I watched the film and I saw it in other people's response. You were tapping into the kind of memories where time did not matter.

MCM: You can understand that the film has been shown only in very limited circumstances. The only country it's ever been shown in is Ireland, and I am extremely touched and quite overwhelmed by the powerful response to the film. Obviously, it does touch on something and it's interesting that I feel like there are certain things that I have

been able to do, so it is a question of trying to find a balance about things in one's relationship with the viewer. The film is, I go to the place and I choose the subject, but I don't go there with a plan of how to make that film . . . There's nothing funny about it at all, there's nothing concrete about it. I'm not trying to teach anybody. It was just me and the camera and a light meter. I had no idea if I was going to get any picture at all and you don't know for months. At that time there was an overwhelming sense of risk – I could easily have ended up with forty rolls of blank film. But there's something fascinating about this process which I came to understand through my years studying John Cage. It's about being passive to situations and not trying to do too much. When I was teaching, I found myself sometimes telling students to stop trying to be so creative. You need to allow something to happen rather than try to make it happen, and I had no idea how to make anything happen . . .

RT: This concept of experience within this world leads us to *An Oak Tree* (1973). This work is the most iconic of many pieces that you have done. Is this work based on the concept of transubstantiation, which stems from the Roman Catholic belief in the transformation of bread and wine into the actual body and blood of Christ? *An Oak Tree* could represent a form of belief, a way of understanding the world around us, a notion of faith. By changing the physical function and form of the glass of water, it actually shows us the power of art to construct reality. There are parallels with the work and ideas of Robert Morris.[14] For

14. Robert Morris (b. 1931) is an American sculptor, conceptual artist and writer. He is regarded as one of the most prominent exponents and theorists of minimalism, along with Donald Judd, but he has also made important contributions to the development of performance, land art and installation art. In 1966, he published a series of influential essays, "Notes on Sculpture", in *Artforum*.

Morris, minimalist works (as with his works) are embedded with flashes of the real world, and in doing so acknowledge again the readymade in it with its materiality, form and function. Do you in your practice express the functional use of the images and highlight the practical use of these objects (such as the glass), or maybe you are subverting another message within these motifs? The silent messages within these works may allude to something, which is not being obviously expressed. By this I was thinking of a quote of Wittgenstein: 'by stating clearly that which is expressible, you can indicate that which is inexpressible'.[15] How is that inexpressibility within your work – what do you feel, do you feel it has a place?

MCM: Yes, definitely. I feel this is a very critical question. I'm very suspicious of the whole modern notion of self-expression. If it ever meant anything real, I find now it's become extremely debased. However, having said that, I think what's really important in expression is the aspect of oneself that one cannot avoid. Not that one sets out to be expressive. When one expresses something, there is an aspect of oneself that is so deeply embedded that even if you tried to suppress it, you couldn't. You can't suppress it because very often you don't recognise that you're doing it, because it's so you. It's so much part of your thinking, so much part of your feelings that it just comes out. Take someone like Tracey Emin,[16] whose work is so much about the overt expression of her own autobiographical life, where her intention is to tell as much as possible. And then take an artist like Bridget Riley,[17] whose work clearly sets out to reveal as little as possible, who sees that autobiographical expression as something she does not wish her art to do. It tells you as much about each artist. Bridget Riley's work tells you as much about her as Tracey Emin's work does

about her. Though Riley appears not to want to tell you anything, you know perfectly well she's an extremely rigorous, clear-thinking person who's full of passionate restraint. This is why I think some people would say that her work is cold and impersonal and inhuman, whereas Emin's is warm and emotive. I don't agree and I'm not passing judgement, I'm just saying that I think the two are examples of two different values, two different sets of interests, but one is not more expressive than the other, as both are saying 'I can't be other than who I am.' Similarly, I think my work is deeply revealing about me in terms of my sense, my limitations, my values, my notions. So it definitely doesn't matter if they are foregrounded or not. That's so extraordinary about art. People often worry about whether an artist is a fake or a phoney. The fact is that through the work the truth is always revealed! You can't hide! And that's one of art's most amazing things – it reveals itself.

RT: Going back to the idea about self, I've been thinking about your work *The Box that Never Closes* (1967). Here, this obviously links with Robert Morris's and Donald Judd's constructions of work and respond-

15. Ludwig Josef Johann Wittgenstein (1889–1951) was an Austrian philosopher who contributed several groundbreaking works to modern philosophy, primarily on the foundations of logic, the philosophy of mathematics, the philosophy of language and the philosophy of the mind. Published works include *Tractus Logic Philosophicus* (1921) translated by C. K. Ogden (1922) and *Philosophical Investigations* (1953).
16. Tracy Emin (b. 1963) is an English artist of Turkish Cypriot origin, one of the so-called YBAs of the nineties. She was taught by Michael Craig-Martin at Goldsmiths College, London.
17. Bridget Riley (b. 1931) is one of the foremost English proponents of op art, art exploring the fallibility of the human eye.

ing to this kind of subject matter. Do you feel that your early box forms are more like a self-portrait, or do they represent a different meaning?

MCM: Well, I saw myself in those box forms from the early sixties. At that point, I considered that people like Donald Judd and Robert Morris were already my parents' generation and that they were established artists and the thing they had discovered was now already done. If I was going to do anything interesting, I had to do something that was different from them. Judd's sculptures were very carefully considered manifestations of boxes in their use of particular materials and in the pared down focus on the actuality of the object so that the viewer is asked to look at the thing for what it is itself.

I tried to introduce the question of functionality. So, in my boxes there was always something that the viewer was asked to do. I was inviting them to do the thing that you're not supposed to do – touch the work. Function determines everything about the nature of most of the objects we make. I was trying to use implications of functionality to get the engagement of the viewer to be physical as well as visual. In order for them to understand the work, they had to physically interact with it.

RT: And that's been the backbone of your artistic evolution. A wonderful quote, which has been said about you, is that the world in front of you is extraordinary, but the difficulty is in actually, as an artist, opening that to the world. That's kind of the mantle that you've been given, and I wonder sometimes, do you ever tire of looking at the world in this way? As the philosopher Martin Heidegger once exclaimed, 'what is ever and again worthy of wonder is preserved in its worth by

wonder'.[18] Heidegger explains that the principle of wonder will never cease; there is interplay between concealment and revelation.

It's important to say at this point that the sense of humour and elegant wit within your work is a crucial element.

MCM: I would always be happy if people were able to laugh. I think it's very important. Two of the most amusing artists I can think of are Duchamp and Cage, extremely amusing people, and I always loved the idea that I could get some sense of wit into my work. And you have to understand that humour is wonderfully subversive because you can make a very complex idea palatable and acceptable.

RT: Break down the hierarchy . . .

MCM: You can open a door. What *An Oak Tree* is saying is quite profound about the relationship of things, the relationship of the viewer and the artist and the object, but I deliberately made the text funny, so it wouldn't seem heavy or didactic. The text is a dialogue between artist and viewer, between believer and sceptic. In reading it, you are allowed to be both the believer and the disbeliever. You act out both roles.

With anything I've ever done, I've always had the passion to see what the thing in my mind might look like, and the only way to see what it looks like is to actually do it . . .

18. Here I am quoting Martin Heidegger, *Early Greek Thinking*, translated D.F. Krell and F.A. Capuzzi. Heidegger (1889–1976) was a German philosopher regarded as a major indispensable influence on existentialism, deconstructivism, hermaneutics and post-modernism.

RT: To participate . . .

MCM: . . . yes, to make the object do it . . . so I have never become bored. I change what I do when I feel that the work is becoming boring to me, I change tack . . .

RT: Well, that's just the point – you're not a sculptor or a painter or an installation artist – we're talking about your new pieces with screens. It's all a constant evolution that relates back. But again, you are playing with these devices and using the devices to create this overarching kind of ideology, a language. It's as if your language constantly becomes redefined, and is like an absorbing, inexhaustible encyclopaedia, and these references keep alive the language you create.

MCM: In my early work, I was deliberately trying to be an artist without any style at all. And I thought that it would be possible. To be honest, I found it exhausting, and started to look for a way of working that would be both sustaining and allow me to have a sense of growth. I ultimately found it very frustrating using actual objects precisely because they were not mediated by language. That was the problem – as soon as you do a drawing of a book, it's been mediated by language. Now the book is still the book, still the actual object. The thing that I discovered was that because the real object had not been transmuted into language it became inert in use. It became repetitious and inert and that's when I started to make drawings of the things I had already been using, because I realised that as soon as you made a drawing of something, you could do all those things that the inert object could not do. In other words, once I'd made a work using a glass of water,

every time I used a work featuring a glass of water I was referencing my own work with the glass of water, and it's no longer free of that. On the other hand, I can do a drawing of a glass of water – I have a drawing of a glass of water and I have used it in many pictures – and though it may make a particular connection it doesn't have to. I can make an image five stories high or the size of a postage stamp. I can make it green and purple, upside down. I can do anything, because these are manipulations that language allows.

RT: I would like to bring you back to the language of scale, because many of your sculptures in the fifties all relate to the human sense of scale. In comparison to the public art work *Big Fan* (2003) in Regents Place, London.[19] I'm interested in how scale relates to human proportions, and the measurement of our body physically against the size of the work.

MCM: When I first started to do wall paintings and installations using images of the objects, I made the walls bright colours for multi-rooms, but I made the images actual size and pseudo-naturalistic browns and beiges. This was because I wanted them to be human scale, so that when I put them in a room I put them back into the scale the real thing would have been – so the chair was chair sized, the book was book sized and whatever. However, I started to realise after time that this was a denial of the potentiality of them as language, and then I started to realise I could make a pair of shoes the same size as the room

19. Michael Craig-Martin, *Big Fan* (2003), Regents Place, London, 16.4 x 12.4 m.

itself! And I could make them purple or I could make them yellow, which is what the language of image-making allows. And of course, the fact is that if you make a pair of shoes five metres high on a wall, it has an enormous impact on the person who views them. We are so overwhelmed, so fascinated by scale changes.

I've been very drawn to the idea of public art I like the idea of art in circumstances where one doesn't expect to find it, and I think the idea of public art in our time is not an easy thing. There are a few things that have been successful, and I feel that particularly in the realm of pictorial art – i.e. two-dimensional art – the world has simply been handed over to advertisers. My aim is to try to enter the realm and mechanisms of this world with things that are not advertisements, but that have used the languages and the techniques that have been developed through the advertising industry.

RT: You infiltrate that world. Another artist that has done that as well and with whom you have similar parallels to some extent conceptually is Pierre Huyghe. The situationist and conceptual elements are evident in works like *Chantier Barbés-Rochechouart*, Billboard, Paris (1994). Here, Huyghe illegally constructed and placed billboards displaying workers at construction sites. These billboards were unspectacular and unglamorous; they showed a snapshot from everyday life at that site, an antidote to the false promises of the advertising industry. He superimposed two realities: the real – the construction in progress – and the recorded simulacrum – the blown-up image. This work is about deconstructing medium by message.[20] At the same time with Huyghe's pieces, which I adore, you have to really work at the message. Is there any similarity with your and Huyghe's ideas of infiltration of reality?

MCM: I've always liked the idea that everything can be absurdly explicit, and there's a way in which I think you can't do anything that's too dumb. You know something can be too complicated. However, you cannot make something too simple . . .

RT: . . . paring it down to its absolute form, here there are parallels between your pieces and Judd's work, or what do you feel about the darker element?

MCM: Judd understood so much about the psychology of experience. I feel his work is very disturbing. In general, one of the reasons I stayed away from the idea of making images of things in my earlier work was because I thought that the immediacy could only occur if the confrontation was a real thing. If Judd presents you with a confrontation with an actual object, you have an actual experience of the actual object in your actual real time, which is a real time frame. This is very much an idea of the sixties – a real object in a real time frame – and my thinking is part of that frame. In that way, the only painting that was really susceptible to that way of thinking was the painting as object, which very often involved painting as a monochrome and was very resistant to the idea of painting using images (so much so that there are none). Most painters of this time don't make paintings using imagery. One of the things that was a great revelation to me in the late seventies was a philosophical essay about picturing, and the thing that

20. Pierre Huyghe (b. 1962) is a French artist who works in a variety of media from film and video to public interventions.

was overwhelming to me was the discussion about the nature of pictures as being actively participatory by the viewer. One of the things that I tried to understand is how we see a picture of something. For example, a picture of a hammer doesn't actually look like a hammer at all, but the reason why it looks like a hammer is the capacity that is in the viewer, not a characteristic that is in the picture.

I can do a simple outline of things, a line drawing of things. And I don't need to tell you that this is a picture of a light bulb or a mobile phone and that they are different and they have different functions and are made out of different materials. I don't tell you any of that. You carry that with you . . . you are already embedded. And I'm using that in exactly the same way that Warhol used Marilyn Monroe. When he takes this image of Marilyn Monroe, this given image, he doesn't need to tell us anything about Marilyn Monroe, because everything we know of Marilyn Monroe we bring to this painting. He doesn't need to bring it to us – just a hint of Marilyn Monroe and we're off. I try to capture something similar, but with ordinary objects . . .

RT: This recognisibility leads me again to the work, and maybe we can talk about this again. There's a feeling of a perceptual break – this may have to do with colour, as obviously the colours we talked about are not just the browns that you used years ago. I think you've got this almost utopian, crazy infatuation with colour that makes one feel – it's so arresting, it kind of draws you back.

MCM: It took me a long time before I got the courage to use colour in the images. My drawings are extremely accurate. I am not making

cartoons, they are not sketches. My drawings are realistic and precise. I want you to be able to really understand that object by looking at my drawings. Almost all are from three-quarter perspective, looking from above, which reveals most of the three-dimensional quality of an object. So they are all seen from a very similar point of view, although each one is drawn separately. I'm literally trying to make the simplest representation of that thing that I can, in as neutral a way as I can, so the line has no personal hand. It has no inflection. It's very plain so as to reveal the object as much as possible.

RT: Could I say for the record as well that you do this yourself, that this is all your painting?

MCM: Well I do all the drawing, but I do have assistance with the painting. Of course I do all the original drawings and even drawing on the canvases. I do all the drawing because nobody can do it as well as me.

RT: I had a conversation with Thomas Scheibitz in Berlin who has a similar perspective, and I was just thinking how rare that is now and it's crucial, he said, as a core thing.[21]

MCM: Yes, I like doing it, and I'm the best at doing it, too. This is going back to the question about what happens when you enter into a world run with language, because, as I said, you can have a five-metre-

21. Thomas Scheibitz (b. 1968) is a contemporary German painter and sculptor.

high glass of water or a half-inch-high glass of water. You can play with all these things, and a part of this is that you can play with colour, which is a part of language within the language of painting. My starting point with colour is that the colour should be very explicit and nameable in the same way as the objects are, so that the colours are red, yellow, blue, black, purple, orange, green, blue . . . so that you can name the object and you can name the colour. I am aiming for nuance here, and to do this I try for immediate experience, so the colour is as potent as possible in order to get a greater sense of immediacy. So I try to intensify the moment by using the most brilliant hue of each colour that is possible. That's my initial use of the colour. Now the other thing is that where the drawing is absolutely true to the object, the colour clearly is not, and it is liberated from having to do that because the drawing does that.

RT: We've touched on the role of the artist, something that I'm interested in because I feel that generally the artist may be supplanting roles. Artists may become the new historians of our time, or maybe replace a religious order as well and therefore the artist has greater responsibility that can be related back to the Renaissance ideal where the artist role has to convey immorality and historicism, giving people a way of anchoring themselves and understanding the world. Do you feel that the role of the artist is to uplift or carry through, especially in this fractured world, and what does your art say to people? For the reader of this book, what would your statement say or hope for?

MCM: I think that's a very difficult question. I hate the idea that

artists take on a kind of pseudo-religious role, partly because I have quite a strong dislike for religion. I'm not so interested in this role that has already been cast in such doubt. It seems to me that what art is for . . . because it has a function, too – I don't believe in things not having functions. Everything has a function, and art has a function, too. We do things because we have reasons for doing them. Art seems to give us a very strange way of being able to look at the world, to step outside the world and look at it. If for instance as an artist I feel able to look at architecture, for me to look at architecture is not the same thing as an architect looking at architecture. Just as when Richard Long goes into the landscape he doesn't see the landscape the way a farmer sees the landscape – he sees it quite differently. It seems to me that this is the function, and I know if you are from the visual arts and you go to the theatre, you know the theatre allows people to view human behaviour, to have a look at it . . .

It's about stepping out, a kind of movement to be able to observe. And when you are entirely in the midst of things, it's very hard to see what is actually there. The role of art is to show you what is actually there, what it is that is so very easy to miss because we're so engulfed.

RT: Yes, it appears to me – because initially I thought your work had this Kafkaesque air – which in fact, links back to John Cage and the notion of his 'chance' concept, which has a holistic element of music and art.

MCM: I suppose it's very interesting to me that Cage's ideas about music, about sound, came from what he understood from Duchamp about art and about the notion of art's relationship to ordinary objects

– that anything in the visual world could be art. It was the context and the attempt that gave it its function as art. And Cage did exactly the same thing with music – he took this idea as far as it's possible to go with music. And it's interesting that Cage had such an impact on visual artists. If anything, he had a bigger impact on visual artists than he did on music.

RT: You can see that resonance with the younger generation, pouring through so many strands of practice. Both Pierre Huyghe and Philippe Parreno[22] have made works referencing Cage, like *Silence Score* (1997) and *Le carillon* (1997) and Rirkrit Tiravanija has, too.[23]

To end on Beckett, which I think would be appropriate, do you feel that even though your work has immediacy, it also has this transparency and perhaps is like Beckett's. He shows us the gap between action, thought, word and deed through a prolonged silence. Those quiet moments of silence revealing everything.

MCM: I think just as highly of Beckett now as I did when I was in my early twenties. He understood something so radical about the theatre. In the world today, we have an increasing sense of unease about artifice so that we're very documentary orientated – about the belief that if real people are doing real things that is a true representation of reality. And that fiction – because it is fiction – is somehow false. Whereas the traditional notion of theatre is that it was artificial in order to be more real, to require and enable the suspension of disbelief. What's so striking about Beckett is that his work is completely un-naturalistic, but overwhelmingly real. There is a heightened state of reality, by the simplest means of the theatre. I would

like to feel that I try to do a similar kind of thing – taking the most fundamental elements of art and just bringing them to this heightened state of reality.

RT: Thank you, Michael. For me, this talk has clarified the continuing sense of wonderment that is elegantly evident in your practice. And, however fleeting the moment is when we view your work, ultimately, it is an affirmation of what it means to be human.

22. Philippe Parreno (b. 1964) is a contemporary French artist part of a group known for instigating the movement Relational Aesthetics.
23. Rirkrit Tiravanija (b. 1961) is an Argentinean artist living and working in New York and Berlin and is part of a group known for instigating the movement Relational Aesthetics.

Works

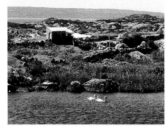

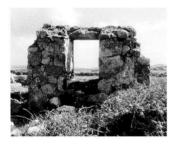

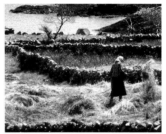

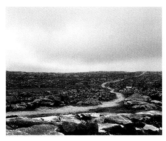

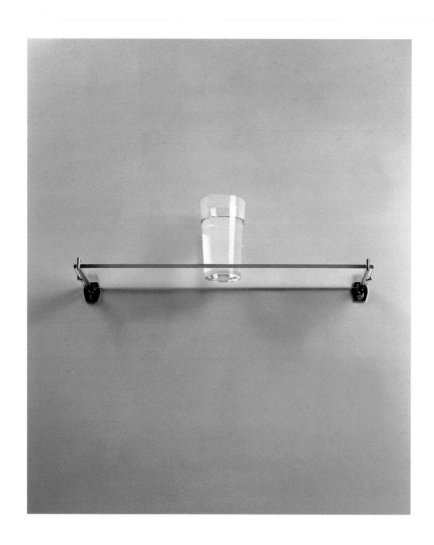

Q: To begin with, could you describe this work?

A: Yes, of course. What I've done is change a glass of water into a full-grown oak tree without altering the accidents of the glass of water.

Q: The accidents?

A: Yes. The colour, feel, weight, size…

Q: Do you mean that the glass of water is a symbol of an oak tree?

A: No. It's not a symbol. I've changed the physical substance of the glass of water into that of an oak tree.

Q: It looks like a glass of water…

A: Of course it does. I didn't change its appearance. But it's not a glass of water. It's an oak tree.

Q: Can you prove what you claim to have done?

A: Well, yes and no. I claim to have maintained the physical form of the glass of water and, as you can see, I have. However, as one normally looks for evidence of physical change in terms of altered form, no such proof exists.

Q: Haven't you simply called this glass of water an oak tree?

A: Absolutely not. It's not a glass of water anymore. I have changed its actual substance. It would no longer be accurate to call it a glass of water. One could call it anything one wished but that would not alter the fact that it is an oak tree.

Q: Isn't this just a case of the emperor's new clothes?

A: No. With the emperor's new clothes people claimed to see something which wasn't there because they felt they should. I would be very surprised if anyone told me they saw an oak tree.

Q: Was it difficult to effect the change?

A: No effort at all. But it took me years of work before I realized I could do it.

Q: When precisely did the glass of water become an oak tree?

A: When I put water in the glass.

Q: Does this happen every time you fill a glass with water?

A: No, of course not. Only when I intend to change it into an oak tree.

Q: Then intention causes the change?

A: I would say it precipitates the change.

Q: You don't know how you do it?

A: It contradicts what I feel I know about cause and effect.

Q: It seems to me that you're claiming to have worked a miracle. Isn't that the case?

A: I'm flattered that you think so.

Q: But aren't you the only person who can do something like this?

A: How could I know?

Q: Could you teach others to do it?

A: No. It's not something one can teach.

Q: Do you consider changing the glass of water into an oak tree constitutes an artwork?

A: Yes.

Q: What precisely is the artwork? The glass of water?

A: There is no glass of water anymore.

Q: The process of change?

A: There is no process involved in the change.

Q: The oak tree?

A: Yes, the oak tree.

Q: But the oak tree only exists in the mind.

A: No. The actual oak tree is physically present but in the form of the glass of water. As the glass of water was a particular glass of water, the oak tree is also particular. To conceive the category "oak tree" or to picture a particular oak tree is not to understand and experience what appears to be a glass of water as an oak tree. Just as it is imperceivable, it is also inconceivable.

Q: Did this particular oak tree exist somewhere else before it took the form of a glass of water?

A: No. This particular oak tree did not exist previously. I should also point out that it does not and will not ever have any other form but that of a glass of water.

Q: How long will it continue to be an oak tree?

A: Until I change it.

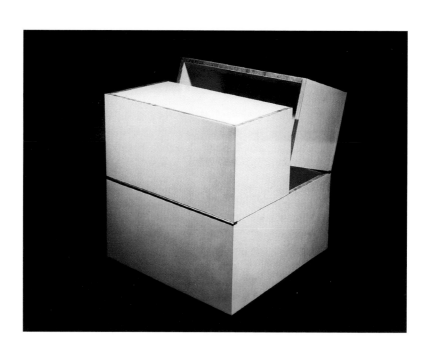

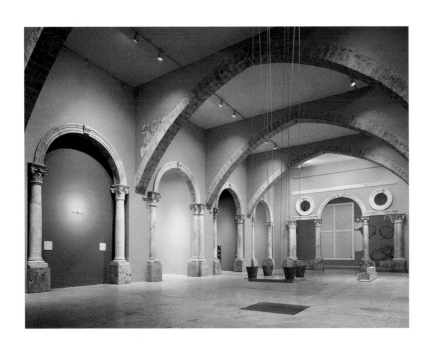

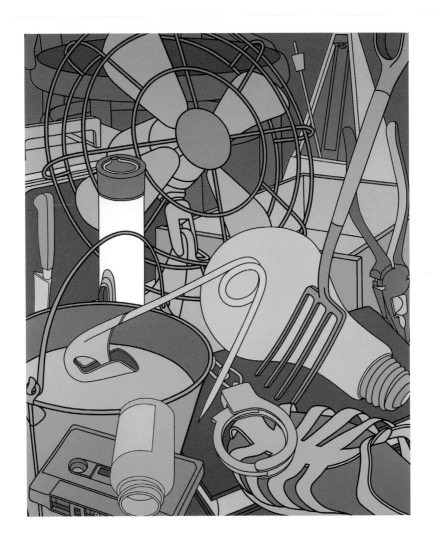

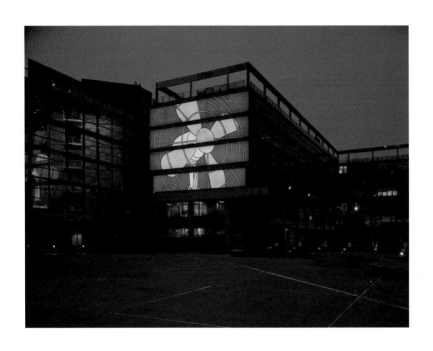

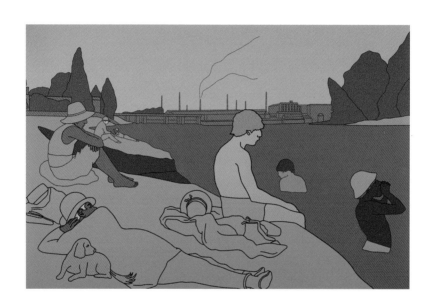

List of Illustrations

Film, 1963
16 mm b/w Kodak film
Collection Irish Museum of Modern Art
Gift of the artist, 2005
p. 49

Box That Never Closes, 1967
Painted block board, brass hinges
Swindon Museum and Art Gallery, Swindon
p. 52

An Oak Tree, 1973
Metal, glass, water, printed text
15 x 46 x 14 cm
Collection Australia National Gallery, Canberra
pp. 50–51

Installation at the Centre del Carme,
September 2000 to January 2001
Courtesy IVAM Institute Valencia d'Art Modern, Valencia
p. 53

Eye of the Storm, 2003
Acrylic on canvas
335.3 x 279.4 cm
Collection Irish Museum of Modern Art
Purchase, 2005
p. 54

Big Fan, 2003
Lightbox at Regents Place, London
Ultralon white 'Flexface', translucent vinyl film and aluminium
20 x 20 m
Courtesy The British Land Company PLC, London
p. 55

Reconstructing Seurat, 2004
Acrylic on aluminium panel
185.42 x 274.4 cm
Courtesy the artist and Gagosian Gallery, London
p. 56

Appendix

Michael Craig-Martin was born in 1941 in Dublin, Ireland.
He lives and works in London.

Solo Exhibitions

2005
ARP / CRAIG-MARTIN / ARP, Arp Museum, Remagen, Germany.

2004
Michael Craig-Martin: Surfacing, Milton Keynes Art Gallery, Milton Keynes, England.
Deconstructing Piero Deconstructing Seurat Folio, Alan Cristea Gallery, London.

2001
Landscapes, Douglas Hyde Gallery, Dublin (site-specific installation).
Living, Sintra Museum of Modern Art, Berardo Collection, Sintra, Portugal.

1999
Michael Craig-Martin: And Sometimes a Cigar Is Just a Cigar, Wurttembergischer Kunstverein, Stuttgart (site-specific installation).
ModernStarts: Things, Museum of Modern Art, New York (site-specific installation).

1998
Michael Craig-Martin: Always Now, Kunstverein, Hannover (site-specific installation).
Michael Craig-Martin, British Pavilion, Ibirapuera Park, 24th International Bienal de São Paulo (site-specific installation).

1997
Michael Craig-Martin und Raymond Pettibon, Kunstverein für die Rheinlande, Düsseldorf (site-specific installation).

1995
Museum of Contemporary Art, Chicago (site-specific installation).

1994
Private Space, Public Space, Centre Georges Pompidou, Paris (site-specific installation).
Wall Paintings at the Villa Herbst, Museum Sztuki, Lodz, Poland (site-specific installation).

1991
Projects 27, Museum of Modern Art, New York (site-specific installation).
Michael Craig-Martin, Musée des Beaux-Arts, André Malraux, Le Havre.

1989
Michael Craig-Martin: A Retrospective 1968–1989, Whitechapel Art Gallery, London.

1981
Galerija Suvremene Umjetnosti, Zagreb.

1979
Oliver Dowling Gallery, Dublin.

1971
Arnolfini Gallery, Bristol.
Richard Demarco Gallery, Edinburgh.

1969
Rowan Gallery, London.

Group Exhibitions

2004
100 Artists See God, curated by John Baldessari and Meg Cranston, Laguna Art Museum, California. Travelled to: Institute of Contemporary Art, London.
Drawings, Gagosian Gallery, London.

2002
Blast to Freeze, British Art in the 20th Century, Kunstmuseum, Wolfsburg, Germany.

2000
Live in your Head, Whitechapel Art Gallery, London. Travelled to: Museo do Chiado, Lisbon (through 2001).
Intelligence, New British Art 2000, Tate Britain, London (site-specific installation).
Die scheinbaren Dinge, Haus der Kunst, Munich (site-specific installation).
Voilá le Monde dans la tête, Musée d'Art Moderne de la Ville de Paris, Paris.
Shifting Ground, Irish Museum of Modern Art, Dublin.

1995
The Adventure of Painting, curated by Martin Hentschel and Raimund Stecker, Kunstverein,

Düsseldorf, and Kunstverein, Stuttgart (site-specific installations).

Drawing the Line: Reassessing Drawing Past and Present, selected by Michael Craig-Martin, National touring exhibition from South Bank Centre; Southampton City Art Gallery, Manchester City Art Gallery, Fernes Art Gallery Hull and Whitechapel Art Gallery, London, England.

1994
Wall to Wall, Serpentine Gallery, London (site-specific installation).

1993
Cut of Sight, Out of Mind, Lisson Gallery, London.
Here and Now, Serpentine Gallery, London.

1991
Objects for the Ideal Home: The Legacy of Pop Art, Serpentine Gallery, London.

1990
The Readymade Boomerang, curated by Rene Block, Sydney Biennale.

1988
Starlit Waters: British Sculpture, on International Art 1968–1988, Tate Gallery, Liverpool.

1987
Vessel, Serpentine Gallery, London.
Wall Works, Cornerhouse Gallery, Manchester.

1986
Entre el Objeto y la Imagen - Escultura britanica contemporanea, Palacio Velazquez, Madrid. Travelled to: Barcelona; Bilbao.

1984
1965–1972 - When Attitude Became Form, Kettle's Yard Gallery, Cambridge, and Fruitmarket Gallery, Edinburgh.

1983
New Art, Tate Gallery, London.

1982
Aspects of British Art Today, Metropolitan Art Museum, Tokyo. Travelled through Japan.

1981
Malmoe, Konsthall, Malmö, Sweden.

Construction in Process, Lodz, Poland.
British Sculpture in the 20th Century, Whitechapel Art Gallery, London.

1980
ROSC, University College Gallery and National Gallery of Ireland, Dublin.

1979
Un Certain Art Anglais (organised by ARC II and the British Council), Musée d'Art Moderne de to Ville de Paris, Paris.

1977
Documenta VI, Kassel, West Germany.
Hayward Annual: Current British Art Part II, Hayward Gallery, London.

1976
Art as Thought Process, XI Biennale International d'Art, Palais d'Europe, Menton, France.

1974
Idea and Image in Recent Art, Art Institute of Chicago, Chicago.

1973
Art as Thought Process, Serpentine Gallery, London.
Henry Moore to Gilbert & George, Palais des Beaux-Arts, Brussels.

1972
7 Exhibitions, Tate Gallery, London.
The New Art, Hayward Gallery, London.

Commissions

2004
Milton Keynes Gallery, Milton Keynes, England (exterior painting).

2003
The Big Fan, The British Land Company PLC. Regents Place, Euston Road, London. Largescale digitally produced image on vinyl in lightbox. Architects: Sheppard Robson.

2002
Laban Dance Centre, London, artist consultant to architects Herzog & deMeuron and site-specific installation (large-scale

digitally produced image on vinyl).
Manchester Art Gallery. Installation
commissioned to mark the reopening of
Manchester Art Gallery.

2000

British Embassy, Moscow (painting on canvas).
Architects: Ahrends Burton.
British Council Building, Berlin (ceiling
painting). Architects: Sauerbruck Hutton.
Royal Mail – design of Millennium
commemorative postage stamp (theme: right to
health).
Museum of Modern Art, New York, digital
artwork (screensaver).
Museum of Modern Art, New York, special
millennium poster.

1999

Milton Keynes Theatre and Milton Keynes
Gallery, Milton Keynes, England (metal relief).
Swiss Light, Tate Modern, London (collaboration
with architects Herzog & deMeuron).

1994

Tokyo International Exhibition Center, Tokyo
(wall painting, through 2005).

1992

Ballet Rambert, set and costume design for
Gone, choreographed by Mark Baldwin,
premiered at Royal Northern College of music,
Manchester.

Teaching

1974–1988

Full-time teaching post, Goldsmiths College of
Art, London.

1994–2000

Millard Professor of Fine Art, Goldsmiths
College, London.

Awards and Honours

1989

Appointed Trustee of the Tate Gallery, London.

Bibliography

Selected Books and Catalogues

2004

Lerm Hayes, Christa-Maria. *Joyce in Art.*
Dublin: Royal Hibernian Academy.
McEvilley, Thomas. *100 Artists See God.* New
York: Independent Curators International.
Noble, Richard. *Michael Craig-Martin Surfacing.*
Milton Keynes: Milton Keynes Gallery,
England.
Richards, Judith. *Inside the Studio: Two Decades
of Talks with Artists in New York.* New York:
Independent Curators International.
Stecker, Raimund. *The Paintings of Josef Albers.*
London: Waddington Galleries.
Stecker, Raimund. *ARP-CRAIG-MARTIN-
ARP 11 Reliefs/11 Paintings/11 Sculptures.*
Remegen: Arp Museum.

2003

Eye Of The Storm. New York: Gagosian
Gallery.
Dannenberg, Hans and Klaus Frierichs
Eckhard. *Michael Craig-Martin: Installation in
the Medieval Collection of the Buxtehude
Museum.* Buxtehude: Buxtehude Museum.
Judin, Juerg. *Workplace – Michael Craig-Martin.*
Zurich: Galerie Judin.

2002

Button, Virginia and Richard Cork.
Inhale/Exhale. Manchester: Manchester Art
Gallery.

2001

Nobre Franco, Maria and Isabel Carlos. *Living.*
Moderna: Coleccao Berardo Collection, Sintra
Museuo de Arte.
Juncosa, Enrique. *Micheal Craig-Martin.*
Valencia: IVAM Centre del Carme.
Walker, Dorothy, John Hutchinson and Oliver
Dowling. *Landscapes – Michael Craig-Martin.*
Dublin: The Douglas Hyde Gallery.

2000

Intelligence: New British Art. London: Tate
Britain.
Juncosa, Enrique. *Michael Craig-Martin: Confer-*

62

ence. London: Waddington Galleries.

1999
Hentschel, Martin. *And Sometimes A Cigar Is Just a Cigar*. Stuttgart: Kunstverein.

1998
Maloney, Martin. *Michael Craig-Martin*. São Paulo: The British Council Bienal de São Paulo.
Schneider, Eckhard and Yehuda Safran. *Always Now*. Hannover: Kunstverein Hannover.

1997
Craig-Martin, Michael. *Drawing the Line*. London: Whitechapel Gallery.
Mulder, Jorge and Rui Sanches. *Treasure Island*. Lisbon: Calouste Gulbenkian. Foundation.
Searle, Adrian. *Innocence and Experience*. London: Waddington Gallery.
Stecker, Raimund and Katya Blomberg. *Michael Craig-Martin/Raymond Pettibon*. Düsseldorf: Kunstverein Düsseldorf.
Buck, Louisa. *Moving Targets: A User's Guide to British Art Now*. London: Tate Gallery.

1996
Giving Permission. London: Goldsmiths College.
Abadie, Daniel. *Un siècle de sculpture Anglaise*. Paris: Galerie Nationale du Jeu de Paume.

1994
Kaiser, Franz. *Michael Craig-Martin*. Paris: Centre Georges Pompidou.

1991
Cohen, Françoise. *La Recherche de l'evidence*. Le Havre: Musée des Beaux-Arts.
Evren, Robert. *Michael Craig-Martin*. New York: Museum of Modern Art.
Livingstone, Marco. *Objects for the Ideal Home*. London: Serpentine Gallery.

1990
Bloch, Rene. *Sydney Biennale*. Sydney.
Cooke, Lynne. *A Painting Show: Michael Craig-Martin, Gary Hume, Christopher Wool*. London: Karsten Schubert Gallery.
Livingstone, Marco. *Pop Art; A Continuing History*. London: Thames & Hudson.

1989
Cooke, Lynne and Robert Rosenblum. *Michael Craig-Martin*. London: Whitechapel Art Gallery.
Lampert, Catherine. *Michael Craig-Martin: A Retrospective 1968–89*. London: Whitechapel Art Gallery.

1984
Thompson, Jon. *The British Art Show*. London: Arts Council/Orbis.

1982
Lynton, Norbert. *Michael Craig-Martin*. London: British Council Fifth Triennale India.

1978
Mc Ewen, John. *10 Works 1970–1977*. Brisbane: Brisbane Institute of Modern Art.

1972
Seymour, Anne. *The New Art*. London: Hayward Gallery.

To find out more about Charta,
and to learn about our most recent publications, visit

www.chartaartbooks.it

Printed in July 2006
by Tipografia Rumor, Vicenza
for Edizioni Charta